THE SONG OF SONGS

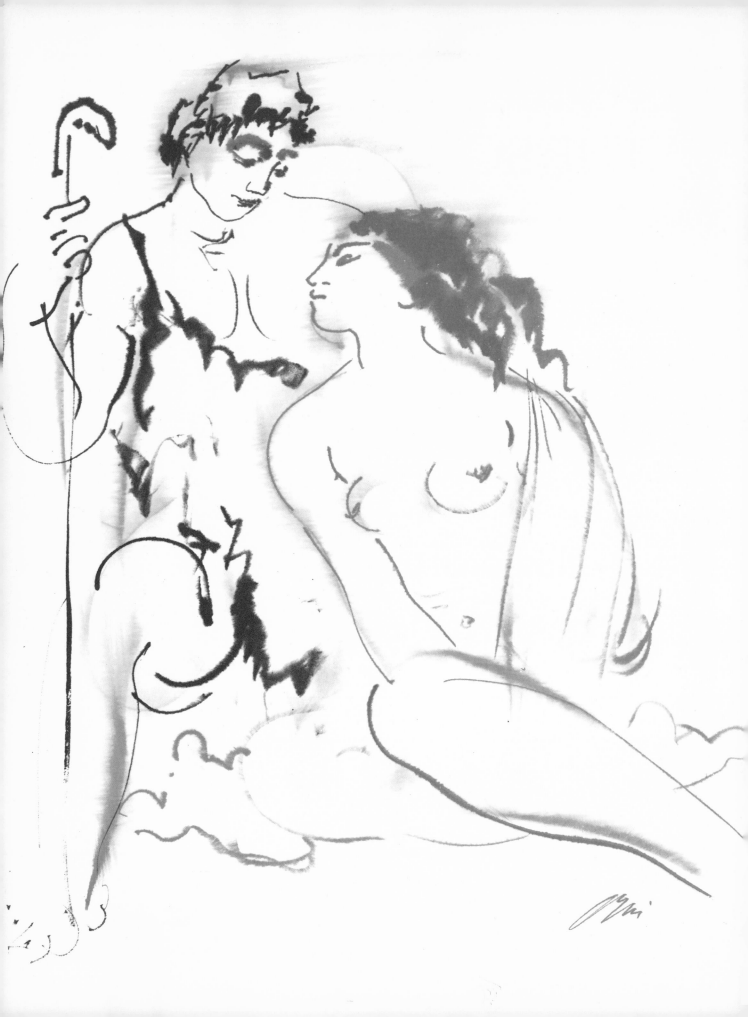

THE SONG OF SONGS

Text and Commentary

by ROBERT GRAVES

Illustrated by HANS ERNI

Clarkson N. Potter, Inc./Publisher NEW YORK

DISTRIBUTED BY CROWN PUBLISHERS INC.

_ In Commendation of Hans Erni _

Hans Erni is one of the few artists alive who could have done justice to the <u>Canticles</u>: indeed, I know none other equally gifted. His distinction is his ability to assist the author in celebrating profound sexual love without the least recourse to pornography.

Swiss birth perhaps explains this. Hans Erni's fellow-countrymen though famous for their powers as sharp-shooters — or perhaps because of it — have avoided war for centuries longer than any other nation in Europe; and it is the militaristic spirit that breeds pornography at the expence of true love.

— Robert Graves —

Designed and produced by the Felix Gluck Press Ltd. Text Copyright © 1973 by Robert Graves, Illustrations Copyright © 1973 by Hans Erni. All rights reserved. No part of this publication may be reproduced, stored in a retrieval system, or transmitted, in any form or by any means, electronic, mechanical, photocopying, recording, or otherwise, without the prior written permission of the publisher.
Inquiries should be addressed to Clarkson N. Potter, Inc., 419 Park Avenue South, New York, N.Y. 10016.
Library of Congress Catalog Card Number: 73-82331
ISBN: 0-517 50801X
Printed in Great Britain
First American edition published in 1973 by Clarkson N. Potter, Inc.

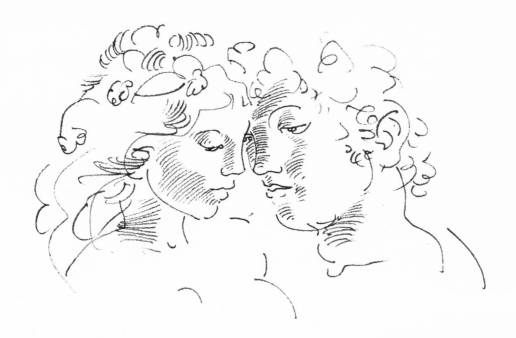

INTRODUCTION

In the title attached to the Canticles, ‹ The Song of Songs which is Solomon's ›, this ‹of› may either denote an intensative, as in ‹Kings of Kings›, ‹Lord of Lords› or ‹Servant of Servants› or simply identify the work as a choral drama. It was, of course, no more the work of King Solomon, who reigned in Jerusalem about 1000 B.C., than Shakespeare's HENRY V *was the work of Henry V.*

The Pharisees had eventually accepted the Canticles in their scriptural Canon as an allegory of the love between Jehovah and Israel; but since the Catholics, though accepting this Canon, ruled that God had finally rejected Israel when the Jews crucified his Son, they reworded the allegory as ‹the love of Christ for his Church›. In 1611 the Protestant editors of King James I's Authorized Version of the Bible followed suit.

Jehovah's marital love for Israel had been an Old Testament commonplace. ISAIAH LXII *speaks well of her in this wifely capacity, but* EZEKIEL XVI *and* XIII *and* JEREMIAH III *present her as an unfaithful trollop and threaten her with damnation. In* HOSEA (I–III) *God is equally vexed with Israel, but forgives her when she has at last been reduced to penury, and promises: ‹I will betroth thee to Me for ever in righteousness and judgement, also in loving-kindness and in mercies. And I will say to them that were not My people: « Thou art My people », and they shall say « Thou art my God ».› This pledge is still ritually confirmed by most married*

1

Orthodox Jews every Sabbath night. The imagery of Hosea's last chapter is like that of the Canticles:

> *O Israel, return to thy God, for thy iniquity has made thee fall.*
>
> *Turn to the Lord and say:* ‹*Forgive my iniquity and receive us graciously*› ...
>
> *Then I shall end their backsliding and love them freely; for my anger is turned away from Israel.*
>
> *I will be as it were dew to Israel, who will blossom like the lily and strike roots like the cedars of Lebanon.*
>
> *Whose branches shall spread, whose beauty shall be as the olive-tree, whose smell is like Lebanon.*

The cedars that strike roots recall the custom in Northern Israel of planting a cedar tree to commemorate the birth of a son.

Dr. Raphael Patai in his carefully documented works MAN AND TEMPLE *and* THE HEBREW GODDESS, *shows that out of the three hundred and sixty years for which Solomon's temple-complex lasted at Jerusalem, the matriarchal Canaanite Goddess Ashera, who represented the old farming population of Israel, had been worshipped there for two hundred and forty as Jehovah's bride and sister, with her wooden image publicly displayed. The tribe of Asher had originally been named in her honour. Dr. Patai points out that when Elijah slaughtered the four hundred priests of Baal on Mount Carmel he left the priests of Ashera unmolested; Baal was then Jehovah's rival male deity and therefore, like Molech, Milcom, Chemosh (*I KINGS XI, 7*) and all other male gods, had to be suppressed.*

The Septuagint Greek version of the Old Testament was undertaken by seventy-two, or some say seventy, Jewish scholars on the island of Pharos close to Alexandria. They worked at the request of King Ptolemy of Egypt, though it is disputed whether this was Ptolemy I (320 B.C.–285 B.C.) or Ptolemy II, called

Philadelphus (285 B.C.–247 B.C.). The work was completed in seventy-two days without, it is said, a single word of disagreement between the translators. According to the LETTER OF ARETEAS, *supposed to date from the reign of Ptolemy II, the scriptural Canon agreed upon by the Seventy omitted the books of* ECCLESIASTES, DANIEL *and the Canticles. Although the* LETTER OF ARETEAS *is now post-dated by scholars to about 132 B.C. we have no reason to reject his testimony about the disputed books, which is supported by the* MISHNA (YADAYIM III, 5). *At the Council of Jamnia, or Jabneh (A.D. 100) the Pharisees' debate on the Canon ended with an impassioned speech by Rabbi Akiba, as the result of which the Doctors of the Law finally found the Canticles worthy of inclusion. Rabbi Simon ben Azay had recalled a tradition that, on the day when the Seventy chose Rabbi Eliezer ben Asarya as their Editor-in-Chief, it was decided that both* ECCLESIASTES *and the Canticles ‹defiled the hands›. Akiba protested: ‹God forbid that there should ever have been a dispute in Israel as to whether the Canticles might defile the hands. The entire history of the world from its beginning to this very day does not outshine the day on which this book was given to Israel. All the Scriptures, indeed, are holy and therefore the hands that they touch seem defiled by contrast; but the Canticles are the Holy of Holies.›*

He meant that it was the sole Hebrew book in sacred use which concentrated wholly on the theme of marital love between man and woman – this being the most important of all religious themes, because prompting the recognition of a deeper love between God and man. Akiba was well qualified to speak on this subject, having begun life as a poor shepherd, a ‹hireling› whose master had been so enraged when his daughter Rachel wished to marry Akiba, that he withheld her dowry. When the two were married despite their poverty, she nobly begged him to leave her and study the Law while

she provided for their child; nor did she encourage him to return until he had become the most learned scholar in Israel.

Akiba will have recognized the Canticles for what it was: a pastoral drama sung at weddings and incorporating ancient folk songs. In it, to judge from the seven-day marriage festivals called ‹The King's Week› described in the last century by von Kremer among the Lebanese villagers and by Wetzstein among the Syrians, the bridegroom plays the part of a king and, on the last day is carried in a decorated litter from his own house to the bride's by a group of bridesmen armed with staves. Bride and bridegroom both wear crowns. (According to the MISHNA (SOTA IX, 14), *the bridegroom's crown was forbidden during the war with Rome that ended with the fall of Jerusalem.) The Jews, of course, have long been supplanted in Syria and the Lebanon by Moslem Syrians, and Hebrew is no longer spoken by the natives; but that there had been similar bridal parades in the streets of Jerusalem and other towns and villages before the Exile, and that the bridegroom and bride sang their own songs on these occasions we know from* JEREMIAH (VII, 34 AND XXV, 10). *The* TALMUD (TAANITH IV, 8) *even records that the Canticles were anciently sung at religious festivals, and the earliest surviving Greek manuscript, the* CODEX SINAITICUS *at the British Museum, assigns the parts, with marginal notes, to Bride, Bridegroom, bridesmaids and bridesmen. It seems however that the eight Bible chapters into which the drama has been divided represent the eight short scrolls on which it was first written, rather than its fifteen natural divisions.*

The Bride played Abishag, a girl from Shunem in Issachar whom (according to the BOOK OF KINGS) *Solomon so strongly desired that he had his brother Adonijah murdered for attempting to marry her. Since at one stage in the drama that Bride dances a sword-dance, the word ‹Shulamite›, here mistakenly used for*

‹Shunemite›, suggests a reminiscence of the Mesopotamian battle-goddess Shulmanitu, whom the Jews had come across during their Babylonian Exile; but it could equally be a female form of ‹Solomon› meaning ‹Solomon's Queen›.

Akiba may himself have been married to the singing of the Canticles. But he must certainly also have known of the New Year marriage rites performed in the Temple; the Bridegroom having been Solomon, or one of his royal descendants, and the Bride a representative of the battle-goddess Anatha for whom he had built the enormous Temple called in KINGS *‹The House of the Forest of Lebanon›. Lebanon is mentioned in the Canticles often enough for the sword-dance to have honoured Anatha long before it honoured Shulmanitu. The sexual act seems to have been represented by the King's use of a fire-drill (of which the emblem was the swastika) to kindle the New Year fire. Early Palestinian myth describes Anatha as the virgin daughter of Ashera, by the northern Semitic bull-god El. Her worship was widespread. The Phoenicians called her Taanith or Neith; the Egyptians, Anath; the Babylonians, Ishtar; the Syrians, Astarte; and the Athenians, Athene. Anatha loved slaughter and would wade up to her thighs in blood, with severed heads as a necklace. The Syrian bride's dance still performed dangerously with a sword in one hand and a scarf in the other, clearly belongs to Canaanite matriarchal tradition; an ancient warning to the bridegroom that, unless he respects her, she will treat him as Jael had treated Sisera, or Judith, Holofernes. In the Canticles the Bridegroom confesses himself scared and compared her to an army in battle order.*

The goddesses Ashera and Anatha were often confused: and this confusion has been found in an Egyptian inscription as early as the 14th century B.C. Moreover the Jewish God Jehovah, originally perhaps Ya-hu (‹Exalted Dove›) a title borrowed from a

Babylonian Creation-goddess, had now come to be identified with El, which made him Ashera's husband and Anatha's father. This transcendental God of Gods incorporating in Himself all seven planetary deities had been invented by Pharoah Akhenaton and, though rejected by his successors, had found a foothold in Israel. And even there, until the Babylonian Exile, Jehovah won the support only of the small obstinate Guild of Prophets and those rare Kings of Judah, such as Jehoshaphat, Hezekiah and Josiah, who abstained from ‹doing evil in the sight of the Lord›. When in the late 6th century B.C. the prophet Jeremiah attributed the capture of Jerusalem and the downfall of Judaea to Jehovah's anger at not having been paid sufficient honour, the people answered that they had sinned not against Jehovah, but against their beloved Anatha, the Queen of Heaven whose worship King Josiah had recently forbidden. They replied: ‹As for what you have told us in the name of Jehovah, we shall not listen to it. But we will without fail do what we have said: we shall burn incense to the Queen of Heaven and pour libations to her as we have always done, — we, our fathers, our Kings and our princes — in the towns of Judaea and in the streets of Jerusalem. For in those days we had food in plenty, enjoyed good health and saw no evil. It is only since we refrained from burning incense to the Queen of Heaven and pouring libations to her that we have lived in want and been consumed by the sword and by famine.›

Elsewhere Jeremiah complains in God's name: ‹In the towns of Judaea and in the streets of Jerusalem the children gather wood, the fathers kindle fires, and the women knead the dough for cakes to be offered to the Queen of Heaven. Also they pour out libations to other gods with the intention of angering Me.›

Under the early monarchy another divine marriage seems to have been annually celebrated between priestly representatives of the god El and the goddess Ashera at the vintage celebration which closed

the sacred year. It was attended by the common people from all over the country who built tabernacles – shacks made of branches, as in the Canticles – all around the Temple and there drank wine and indulged in sexual delights to promote the land's prosperity. This celebration, with the High Priest sleeping in the Holy of Holies, continued until the first century A.D. and the Pharisees were at times unable to keep the festivities within decent bounds: especially since the gift to the Holy of Holies of two new Cherubim of Egyptian workmanship, which had replaced the former sexless angels with only their wings touching: they were male and female figures united in the sexual act. Dr. Patai's recent THE HEBREW GODDESS *emphasises the vast importance that Ashera-Anatha maintained throughout Jewish history under various pseudonyms such as ‹The Shekinah›, ‹The Matronit› and ‹The Sabbath›. It will be noticed that the Bride in the Canticles does not depend on a father, but speaks only of her mother, and with the greatest reverence. In her sword dance as Anatha she honours her mother Ashera without any mention of her father El, and arranges her own bride-price through intermediaries; which is in keeping with the ancient matriachal custom of bringing the bridegroom to the mother's house, rather than bringing the bride to the father's house as in* GENESIS XXIV, 67. *It will be noticed that according to the Canticles it was Solomon's mother, representing the Priestess of Ashera, who crowned him.*

Parts of the Canticles are written in late Hebrew, not earlier than the Seleucid conquest of Israel and Egypt, and under the strong and novel influence of Greek pastoral poetry. This element explains the unlikely description of the Bridegroom as fair and ruddy-cheeked, which recalls Greek pastoral descriptions of Eros. Yet the Bridegroom is compensated by being given hair as black as a raven's plumage. And when the Bride tells her bridesmaids ‹I am black but beautiful› she may be saying that she is beautiful although wise –

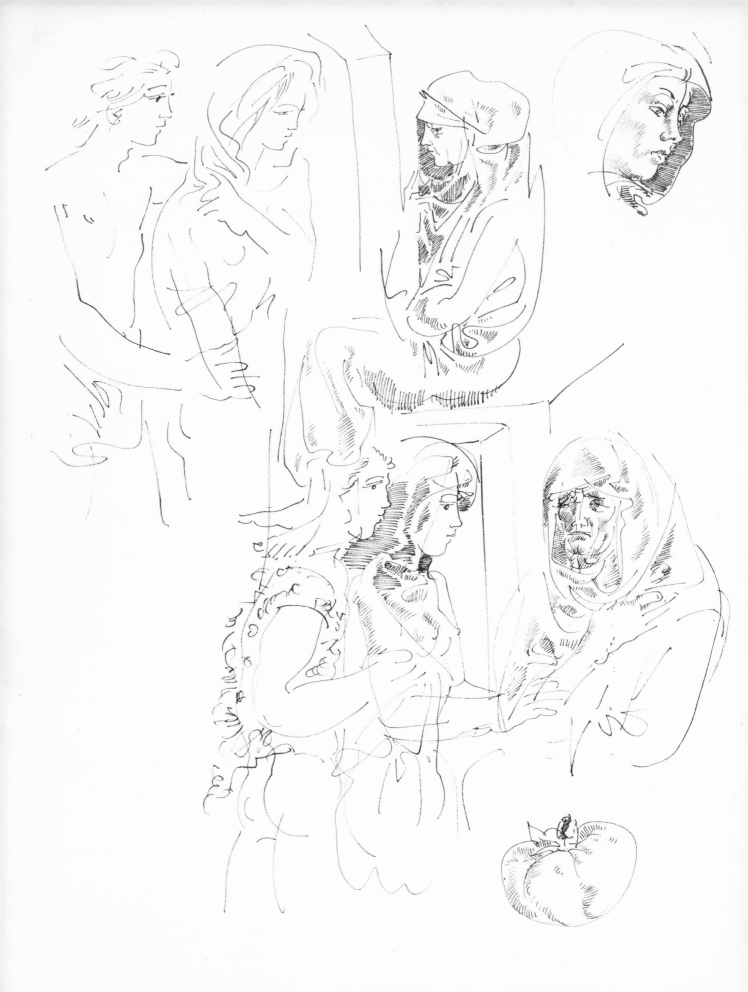

wisdom being a characteristic of age rather than of youth — and the words black and wise being almost indistinguishable in Semitic script. If this is her meaning, the next words ‹For the Sun has gazed upon me› mean ‹I have been enlightened by the prime source of wisdom and love›. And her acclamation in the Canticles likens her to the Moon whose traditional colours are red, white and black — colours also attributed to her by the Bridegroom.

One remark of hers ‹Let us take to ourselves the little foxes that despoil the vines, for our vines have tender grapes› is most ambiguous. The usually accepted sense is: ‹Let us capture the little foxes which spoil our vineyards, because our grapes are tender . . .› In other words: ‹Let us silence all jealousy and envious chatter which threaten our marriage›. The metaphor could have been borrowed from Theocritus who had visited Egypt from Sicily and composed a panegyric on Ptolemy II. He writes in his FIFTH IDYLL (112): ‹I hate the brush-tailed foxes which ruin Nicon's vineyards by biting at his grapes›. These are the foxes in Aesop's fable which cry ‹sour grapes› if too small to reach the clusters. There is, however, an alternative meaning, more appropriate to the passionate occasion, based on JUDGES XV where Samson is, most improbably, said to have captured three hundred foxes, tied them in pairs and set them into the Philistine cornfields with torches attached to their tails. The Palestinian fox does not hunt in packs, and the task of catching, stabling and feeding three hundred foxes would therefore be immensely more laborious and difficult than firing the crops himself. And how could he be sure that the foxes would obediently run into the cornfields with their torches still alight?

Since very few stories in the Bible do not make good sense if examined carefully, it may be that ‹little foxes› is a widespread term for mushrooms of a foxy colour, especially the tasty chanterelles. And, as I discovered during a visit to Israel, other little foxes can

9

still be gathered under the pines on Mount Tabor: namely the fly-agaric (amanita muscaria). The fly-agaric seems to have been sacred to Beelzebub (‹Lord of the Flies›) alias Atabyrius a Hittite god who had an oracle on Tabor. A monk from the Spanish monastry at the summit told me that this mushroom was unspeakably poisonous – a tradition that merely recalled an ancient taboo on the common people's eating of it.

The fact is that the fly-agaric, which has recently been identified by R. Gordon Wasson with the Indian ambrosia called Soma, is highly hallucinogenic. It has two varieties, one with birch as its host-tree, the other which uses the pine. Its juice when taken with wine or beer – as in Dionysus's ancient Feast of Ambrosia – is said to induce reckless courage, sexual lust and super-human energy. Both varieties have scarlet caps which when dried take on a foxy colour; they can then be soaked in water and their juice restored. Since in the Biblical Story of Gideon, three hundred was the strength of an Israelite battalion (namely ten companies of thirty men each), I concluded that Samson had done no more than collect three hundred patriots, dose them with fly-agaric and wine and send them out in pairs, carrying torches to fire the enemy cornfields. Hallucinogenic mushrooms seem always to have been ritually eaten in pairs, but with their stalks discarded. A few days later I asked General Dayan whether he would accept my Samson explanation. He said: ‹Why not? We had a battalion of guerillas in the 1946 War of Liberation called Samson's Foxes.› In this sense of ‹little foxes› – which suits the context a good deal better than the Theocritan sense – the Bride will have been encouraging the Bridegroom to match her in reckless passion like the little foxes with fire in their tails.

The Bride and the Bridegroom will not of course, as their erotic songs suggest, have consummated their marriage before the ceremony;

the Mosaic Law condemned to death by stoning any bride found to be no longer a virgin (DEUTERONOMY XXII, 21). They were dramatically recounting the loves of Solomon and the Shunemite in prospect of what would follow when, their wedding being over, they lay together in the ‹Palace› to which he had invited her – namely a marriage ‹tabernacle› of the sort still built for the ‹King and Queen› in Syria. Solomon's palanquin, described in such glowing terms and given a word borrowed from the Greek, will have in fact, been no more than a simple litter carried by the bridesmen in the wedding play. They clash sticks above their heads, as they go from the Bridegroom's house to the Bride's, impersonating the sixty valiant warriors who had protected Solomon from night attacks. The Bride and Bridegroom are finally enthroned on a threshing board. The ‹thousand shields› used by the men of valour are those mentioned in KINGS XIV, 25–28 as having been borne by the royal guards when the King entered the Temple; they were afterwards returned to store. Dr. Patai has shown that the guards also used them in an annual race. The Bride's two songs recording a bad dream that her beloved had left her, are perhaps, adapted from ancient songs of Anatha-Ishtar's mourning search for Tammuz after he had been killed by a wild boar on Lebanon.

The three verses, near the close of the Canticles, about the little girl who has joined the bridesmaids, and whose breasts have not yet budded, seem to have crept into the play by a happy accident – a local extempore which remained embedded in the text. The Bride's wish that the Bridegroom were her little brother, so that she could kiss him without shame, means that the wish had come upon her when they first met and before the question of marriage had been raised. The Bridegroom's invitation to his bridesmen to get drunk with him is consistent with Biblical custom (see GENESIS XXIX, 22). Solomon would no doubt have been too royal for any such lowering

of his dignity – Israelite kings never appeared except with full regalia – though Alexander the Great was notoriously capable of it. And when the Bridegroom boasts of the sixty wives, eighty concubines and numerous virgins in his harem, none of whom could compare with the Bride, this is of course merely part of the play. The account of her welcome by princesses and queens of Solomon's court is borrowed from PSALM XLV, *where she represents Israel. And in* ECCLESIASTES II, *another late book professedly written by Solomon himself, an account is given of Solomon's vineyards, gardens, orchards and their water supplies.*

Since, therefore, the Canticles conform with descriptions of the modern Syrian and Lebanon seven-day wedding-ceremonies; and since there was no ancient Hebrew theatre – though indeed JOB *is an actionless theatrical dialogue – it is difficult to accept the complicated plot suggested by some critics. They hold that the Bride had rival suitors, namely King Solomon and a simple shepherd, and that she had settled for the shepherd after an escape from being violated by the King's soldiers in a walnut grove.*

The flower names in the Canticles are difficult. ‹Lily› may refer to any one of several flowers, including narcissus. The ‹Rose of Sharon› is a clear mistranslation, and since the mountains to the north of Israel were red with the wild anemones known as the blood of Tammuz – Anatha's lover whose death was yearly mourned at the weeping wall of the Temple – I prefer to translate the ‹rose› as anemone. Some prefer ‹crocus›. The Canticles also mention mandrakes which give off a pleasant smell in the Bride's garden. The mandrake, which belongs to the belladonna family, has been used immemorially in the East as an emitic, narcotic, purgative and anti-spasmodic; and its forked root is held to be oracular. It is, in fact, Shakespeare's ‹drowsy herb mandragora› and many ancient legends attatch to it. The flower, which appears in February or

12

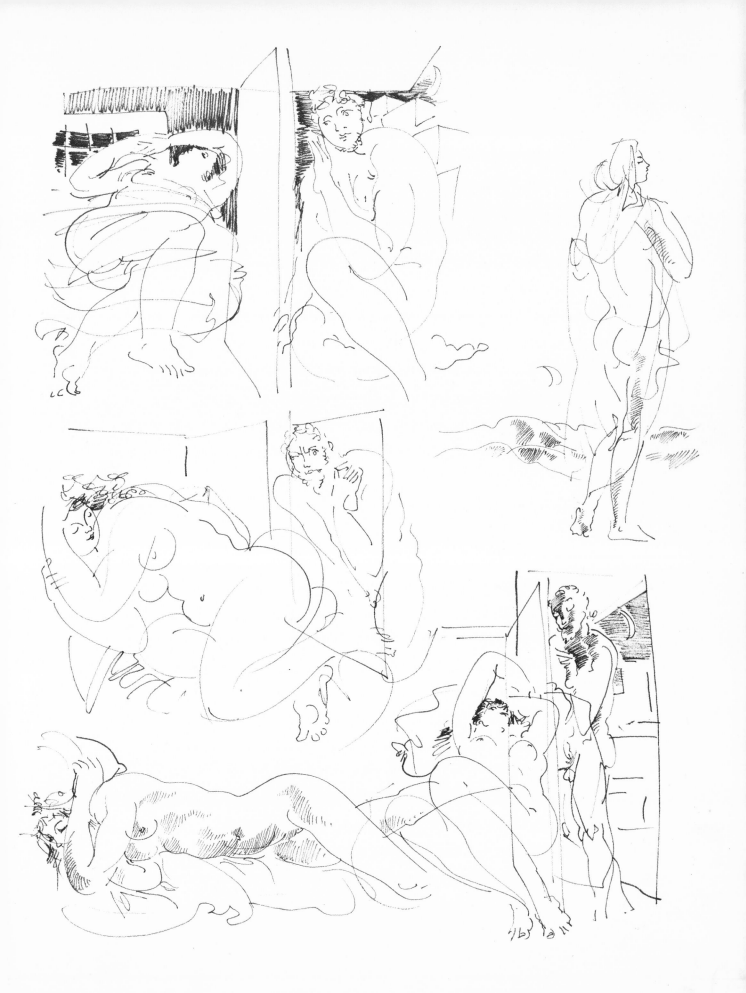

March, the month of marriage, is purple, cup-shaped and scented; the fruit is orange-yellow and sweet-tasting. Its Hebrew name dudaim *implies that it was used as a love charm. The Bride here mentions the mandrakes not only for their scent but because they were believed to ensure conception: as in the story* (GENESIS XXX, 14–23) *of Rachel and Leah's quarrel about the mandrakes, found by Leah's son Rueben, which resulted in the birth of Joseph. For ‹apple› one must read ‹quince›. The apple did not grow so far south as Israel in Hellenistic times; but the quince did and was everywhere sacred to the love-goddess and eaten at weddings as an aphrodisiac. The rock-dove is mentioned in the Canticles as a love-symbol because it is monogamic. Their highly sexual imagery is reminiscent of the Syrian love-lyrics that Meleager contributed to the* GREEK ANTHOLOGY *— he was a native of Gadara, on Lake Tiberias.*

The play ends with the question of a marriage-settlement between Bride and Bridegroom supported by his bridesmen. She is offered a bride-price of a thousand silver staters. The guardians of the orchard, who are to get ten per cent, are presumably her jealous brothers. The Bridegroom calls on her to reply. It is not enough for her to nod acceptance: he demands to hear her voice. The natural perfection of her answer is not commented on by any of the scholars whom I have consulted. She accepts his previous promise to lie all night between her scented breasts but refuses to discuss money. All she will say is: ‹Let us get away from this crowd and afterwards consummate our love in secret.› She refers to the wild goat and hart that go away into the wooded hills and can never be caught mating — any more than the female of either is ever caught dropping its young (JOB XXXIX). *The command, three times repeated in the Canticles: ‹I charge you in the name of the fallow deer and the gazelles not to rouse or disturb my love› is the same plea for absolute privacy in love-making. This sense of privacy is combined*

*in the Canticles with a great sense of reverence. The Bridegroom
addresses her as his sister, an endearment which the Bride
reciprocates by saying that when they first met she used to wish he
was her real brother so that she could kiss him without reproach.
Tobit does the same, calling his wife ‹sister› as a proof that theirs
is true love not merely physical desire* (TOBIT VIII, 4).

*The effect of the Canticles on Catholicism has been curious. God
in Hebrew has a masculine gender (as does* Deus *in Latin and* God
*in Anglo-Saxon); but when, under the Roman Church, the originally
bi-sexual Jehovah, who claimed to have created man and woman in
his own image, became worshipped as wholly patriarchal, the
natural result was religious transvesticism. Priests and monks were
encouraged by their female garments and a vow of celibacy to take
Christ's male love of the Church over-literally: the mediaeval
Spanish St. John of the Cross, for example, identified himself in his
poems with the Bride of the Canticles rather than the Bridegroom.
According to Jerome, Origen of Alexandria who was the first learned
textual commentator on the Scriptures, had ‹surpassed himself in his
ecstatic comments on the Canticles›; and Origen, when a young
man, had taken too literally Jesus's advice* (MATT. X, 12) *to make
himself a eunuch for the Kingdom of Heaven's sake. He did this in
order to instruct his female converts without embarrassment; but
regretted it ever afterwards. Origen, however, lived several centuries
before the Virgin Mary was first identified with Sophia or Wisdom,
who in the* PROVERBS OF SOLOMON (VIII AND IX) *is described as
‹God's Councillor and Workmistress who dwelt with Him before
the Creation›. The many black Virgins in Spain and Southern
France – we have a famous one at Lluch in Majorca – are black
because the Saracen occupation during the Middle Ages taught the
local Christians to equate ‹black› with ‹wise› – hence the ‹Black
Arts› were originally the Wise Arts. Thus it had never occurred to*

Origen to make the Canticles (as did later Catholic exegetists) an account of the love between God and the Virgin of Wisdom which resulted in the immaculate birth of her son Jesus Christ.

The date of the Canticles, if the MISHNA *tradition is acceptable, will have been about 300 B.C. — a century and a half before the Pharisees gained religious ascendency under the Hasmonean Queen Alexandra. But the non-pastoral songs which it contains sound far more ancient and as if sung along the streets at weddings in Jeremiah's day: or even perhaps in Solomon's Temple to honour a sacred wedding. The writer who assembled the Canticles in their present form is likely to have been an Alexandrian Jew acquainted with Meleager's poems: also with those of the Sicilian Theocritus and other Greek pastoral poets made welcome at the Ptolemaic court. He had perhaps undertaken the task for the use of relatives somewhere in the Lebanon.*

Being no Hebrew scholar, I have accepted whatever informed readings seem to make both poetic and historical sense. Critics complain of a muddled sequence; I cannot understand why.

THE SONG OF SONGS, CALLED SOLOMON'S

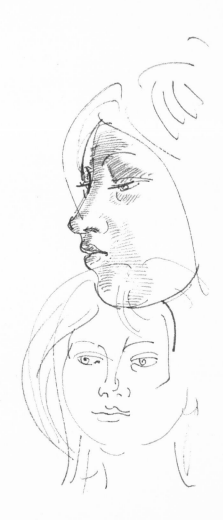

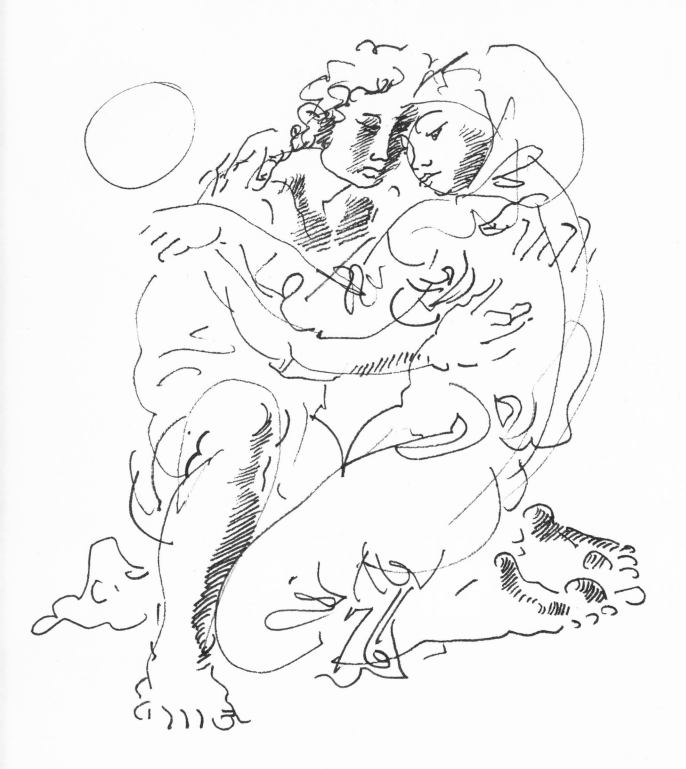

I

Bride:	Let his mouth shower kisses on me...
Bridegroom:	For your breasts are more to me than wine, and are fragrant with the finest ointments.
Bridesmaids:	Your name also has a fragrant smell, as of scented oils lavishly poured; therefore we maidens all love you.
Bride:	Carry me with you!
Bridesmaids:	We will run after you, compelled by your fragrance.
Bride:	The King has summoned me to his Palace!
Bridesmaids:	We will rejoice with you, remembering that your breasts are more to him than wine. All true hearts adore you.
Bride:	I am beautiful, though black, you daughters of Jerusalem: black as the goatskin tents of Kedar or Salmah. Do not scorn my blackness, daughters of Jerusalem! The sun himself has long gazed on me. It was my unkind brothers who set me to mind their vineyards, and thus to neglect my own...

Bride:	Beloved of my soul, tell me where you will dine this noon, where you will settle your flock for their noonday rest. Must I stray after the flocks of your fellow-shepherds?
Bridegroom:	Loveliest of women, do you not already know the place? Then gather your kids, follow in the track of my flock, and let them graze by my shepherds' tents.
	When I am with you, it is as though I were riding in Pharoah's own chariot. Your cheeks are like a dove's breast feathers and your neck like a shining gorget.
Bridesmen:	We will make golden gorgets for you, inlaid with ripples of silver.
Bride:	My beloved is like a bunch of myrrh; he shall lie all night between my breasts. He is also like the blossoms of the henna plant in the vineyards of Engedi.
Bridegroom:	How beautiful you are, my love, how beautiful! You have eyes like a dove.
Bride:	And how lovely you are also, my beloved, and how courteous! Our couch is strewn with blossom, here in our tabernacle with its beams of cedar and ceilings of fir.

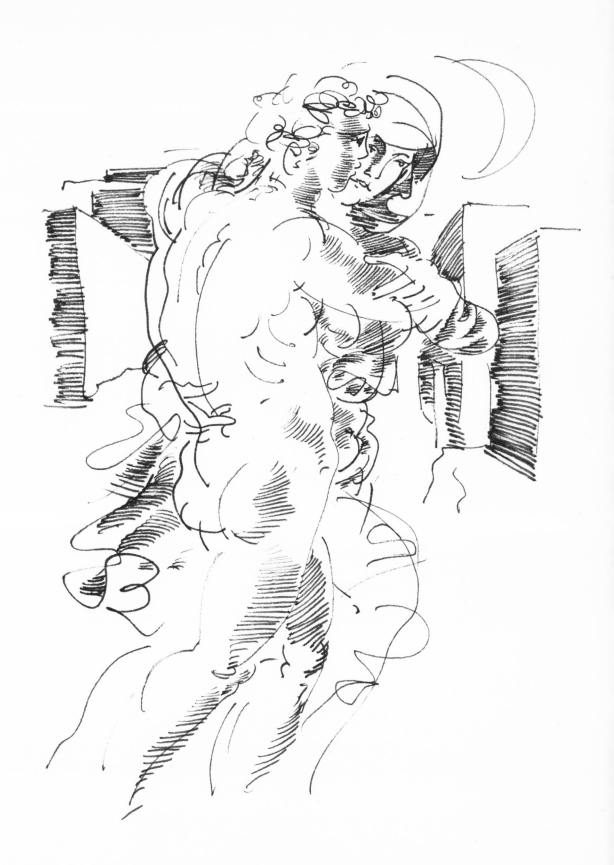

II

Bride: I am the wild anemone, I am the lily of
the valley.

Bridegroom: As a lily among thorns, so is my love in the
company of other maidens.

Bride: As a quince among all the trees of the wood, so
is my beloved in the company of other men.
I sat down in his shade with great delight and
his fruit tasted sweet. He brought me to his
banquet hall and his banner over me was love.
Revive me with grapes, refresh my mouth
with quinces; I faint for love.
His left hand supports my head, his right hand
will fondle me.

Bridegroom: Daughters of Jerusalem, I charge you in the
name of the fallow deer and the gazelles neither
to rouse nor to disturb my beloved; let her wake
when she pleases!

Bride: The voice of my beloved! He comes darting
down from the mountains, leaping over the
hills like a young hart.

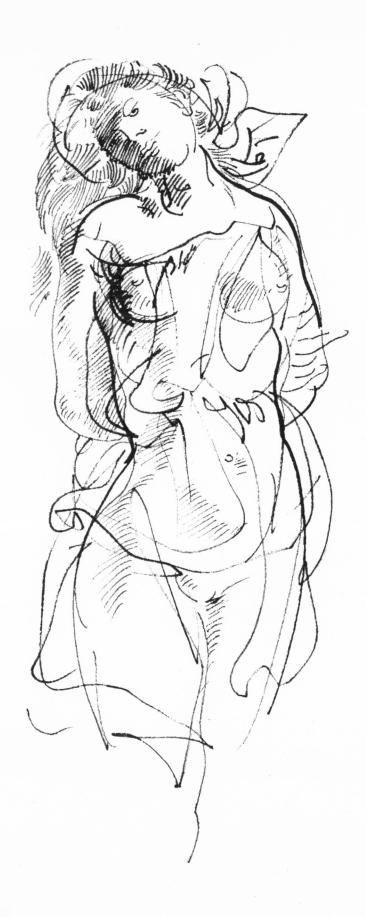

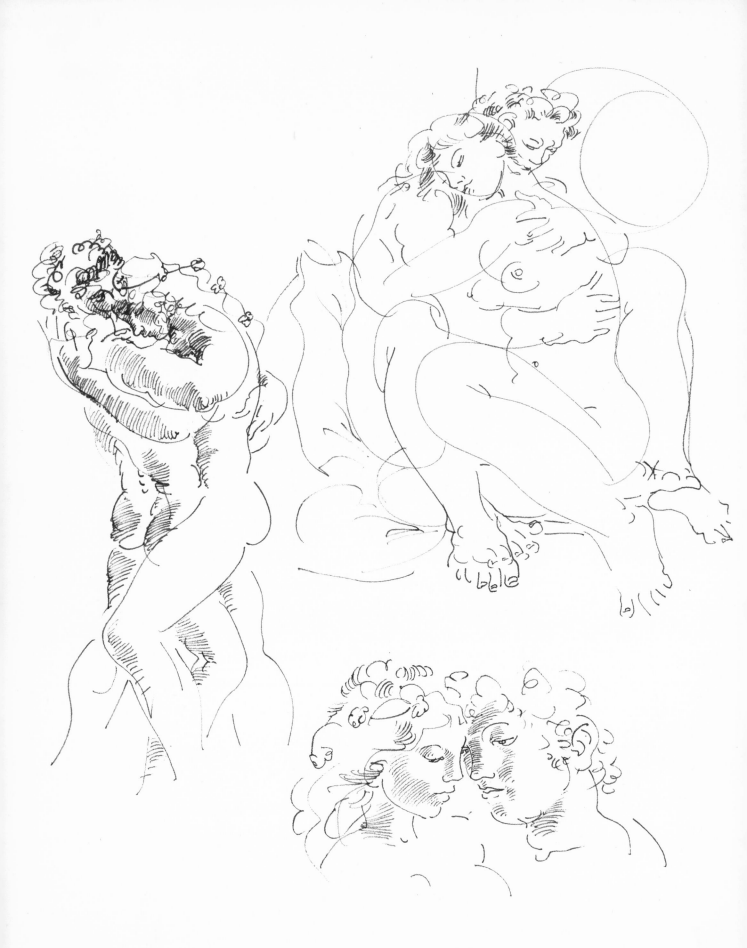

Now he stands outside this house, looking in at
our window, staring through the shutters. Listen,
now he speaks to me!

Bridegroom: Rise up in haste, my love, my dove, my fair one,
and come away! For look, the winter with its
rains has past and gone!
Flowers sprout from the earth, and the time has
come to pluck harp-strings, for the coo of
doves is heard throughout the land.
Young figs sprout from the fig-branches and the
flowering vines have a sweet scent.

Rise up, my love, my beautiful one and come
away!

Bride: Sweet dove, already you are in the cleft of my
rock, enclosed in my cavern.
Look up, let me see your handsome face.
Speak to me, let me hear your sweet voice.

Bridegroom: Let us fetch us little foxes, little foxes that
plunder the vineyards; for our vineyards
are full of grapes.

Bride: My beloved is mine, as I am his. He browses
among my lilies.
Until the day dawns and the shadows fade,
turn again to me, my beloved! Be like a wild goat
or a hart grazing on the hills of Boter.

III

Bride: One night as I lay asleep, though with my heart yet awake, I reached for my beloved, but in my dreams he was not beside me.

I said: 'I must rise and go around the city, searching its streets and houses'.

In my dream I arose and searched the city through but in vain:

The watchmen found me and vainly I asked them: 'Have you seen my beloved?'

Yet I had hardly passed them by before I found my beloved. I seized hold of him crying: 'I will not let you go until I have taken you to my mother's house and brought you into her bedroom'.

Bridegroom: Daughters of Jerusalem, I charge you in the name of the fallow deer and the gazelles, neither to arouse nor disturb my love! Let her wake when she pleases!

Bridesmen: Who is this maiden who rides in from the desert as it were a twig of thyme, perfumed with myrrh and frankincense and all the powders of the perfumer?

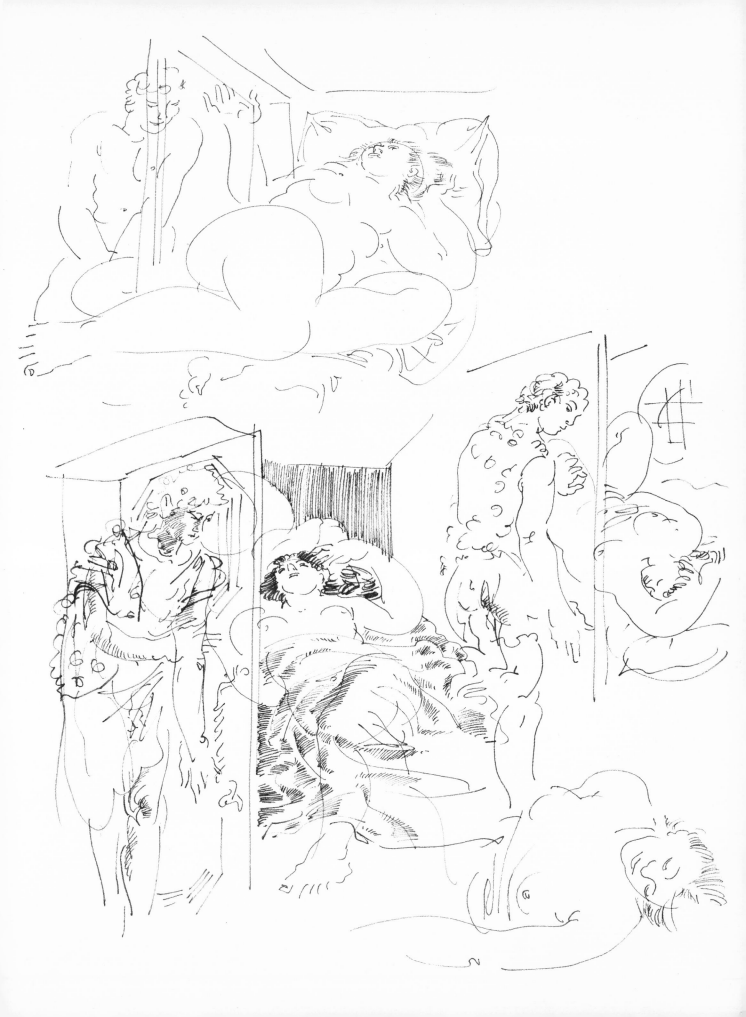

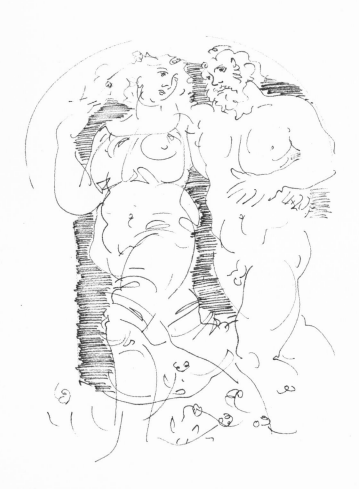

Behold the palanquin of Solomon! Sixty guards
stand about it, the bravest in all Israel, each
with his sword hung at his thigh, against all
night alarums.

Solomon made himself a palanquin of cedar
from Lebanon. Its sides were of silver, its floor
of gold, its steps were lined with purple. The
cushions were furnished for the daughters of
Jerusalem, whom he loved.

Bridesmaids: Let us go out, daughters of Zion, and gaze at
this King Solomon.

He is wearing the diadem with which his mother
crowned him in the day of his betrothal, the
day when his heart rejoiced.

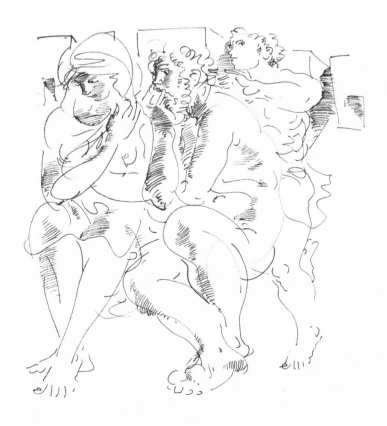

IV

Bridegroom: How beautiful you are, my love, how beautiful!
Your eyes are like a dove's, your hair ripples like
a flock of goats bounding down from Mount
Gilead. Your teeth are white as a flock of shorn
sheep come up from their washing, none of
them barren, all mothers of twins.
Your lips are like scarlet ribbons, your voice
is melodious.
Your cheeks are the colour of a ripe pomegranate—
save for what lies hidden by your tresses.
Your neck is straight and strong like the
battlemented tower that David built; in it hung
a thousand shields, armour for valiant men.
Your breasts are like twin gazelles browsing
among lilies.
Let me now approach the mountain of myrrh
and the hill of frankincense, and there remain
until the day breaks and shadows depart.
You are all beautiful, my love. I find no fault
in you.

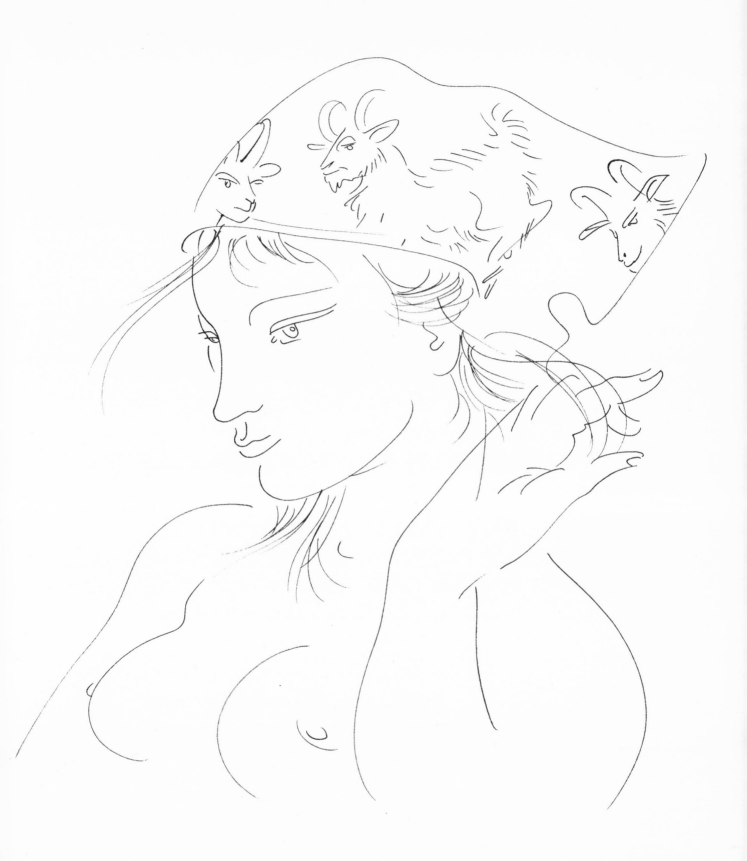

Bridegroom:	Come away with me from Lebanon, my bride! Come away with me from Lebanon! You will be crowned on Mount Amana, and on the crests of Hanir and Hermon, where are lairs of lions and haunts of leopards.
	You have ravished this heart, my sister, my bride. You have ravished it with one glance of your eyes, with one ringlet from your neck.
	How lovely are your breasts, my sister, my bride! They are more to me than wine, and the fragrance of your ointments surpasses all spices.
	Your lips, my love, are like honeycomb; honey and milk flow from under your tongue and your garments breathe incense.
	My bride and sister is like an enclosed garden, a private fountain.
	The garden's produce is pomegranates, with other orchard fruit, also the tree of Cyprus and spikenard.
	Spikenard and saffron, calamus and cinnamon, with incense-trees, with myrrh, aloes and all principal spices.
	She is like a fountain in the garden; a well of living water rushing down from Lebanon.
	Awake, North Wind; approach, South Wind! Blow on my garden and press out the spices.
Bride:	Let my beloved enter my garden and eat the fruits that are his own.

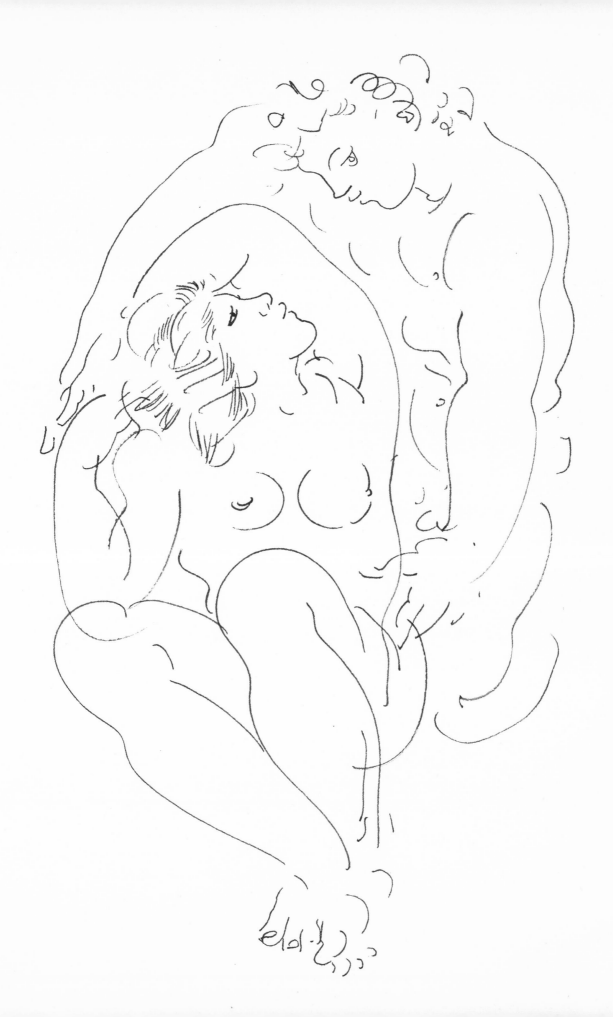

V

Bridegroom: I have entered your garden, my sister, my bride,
 I have culled its myrrh and spices. I have eaten
 its honey-comb and honey, I have drunk wine
 and milk. All were my own.
 Come eat with me, my bridesmen, come drink
 with me and let us all be drunken together
 in comradeship!

Bride: I slept, but my heart was still awake. In dream
 I heard the voice of my beloved. He knocked at
 the door and I heard what he spoke.

Bridegroom: Open the door to me, my sister, my love, my
 dove, my undefiled one. This head is heavy with
 the dews of night, and so are its tresses.

Bride: I answered: 'Already I have taken off my shift,
 must I put it on again? Already I have washed
 my feet, must I again walk in the dust?'
 My beloved put his hand through the door-hole,
 my body quaked at the sound of his fingers.
 I arose to open for my beloved. My hands
 sweated myrrh as also did my fingers, and it was
 myrrh of the purest.
 I drew the bolt to let my beloved enter, but he
 had withdrawn and was gone.

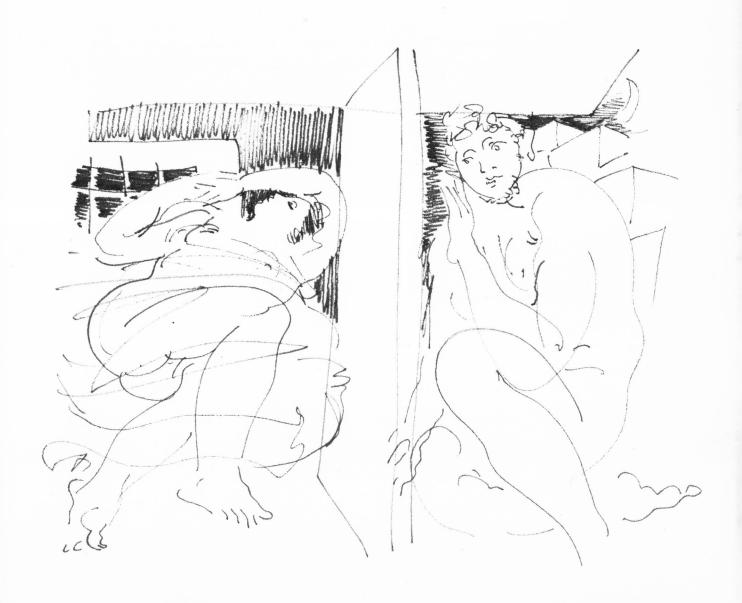

My spirit turned, as it were to water. I looked
for him, but could not find him. I called for him,
but he did not answer.

The city watchmen surrounded me; soldiers of
the garrison snatched away my mantle.

I charge you, daughters of Jerusalem, if you
find my beloved, tell him that I faint for love of him!

Bridesmaids: Describe your beloved to us, most beautiful of
women! How does he differ from any other
beloved, that you charge us with this message?

Bride: My beloved has a fair brow and ruddy cheeks.
He is one in ten thousand. His head appears as
though modelled in fine gold.

His hairs are like palm fronds, though black as
a crow's plumage.

His eyes are like doves flying over streams
washed with milk, and nesting beside copious
torrents.

His cheeks are like beds of spices heaped by the
perfumers.

His lips are like lilies that distil myrrh.

His hands and fingers are as though cast in pure
gold, with beryl gems for the nails.

His belly is like polished ivory, inlaid with sapphire.

His appearance is that of a lofty cedar on Lebanon.

His mouth is very tender and wholly desirable.

Such is my beloved, such is my protector, you
daughters of Jerusalem.

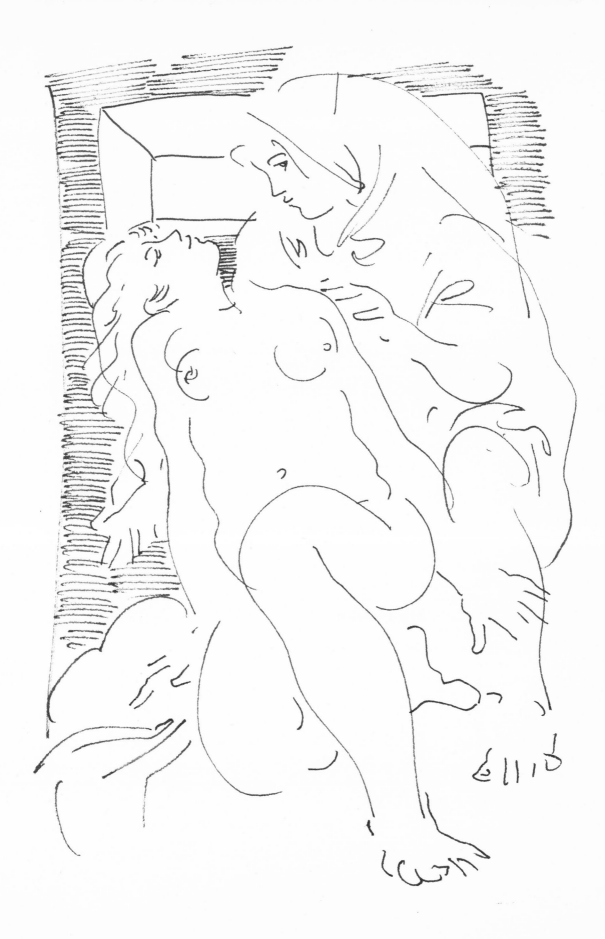

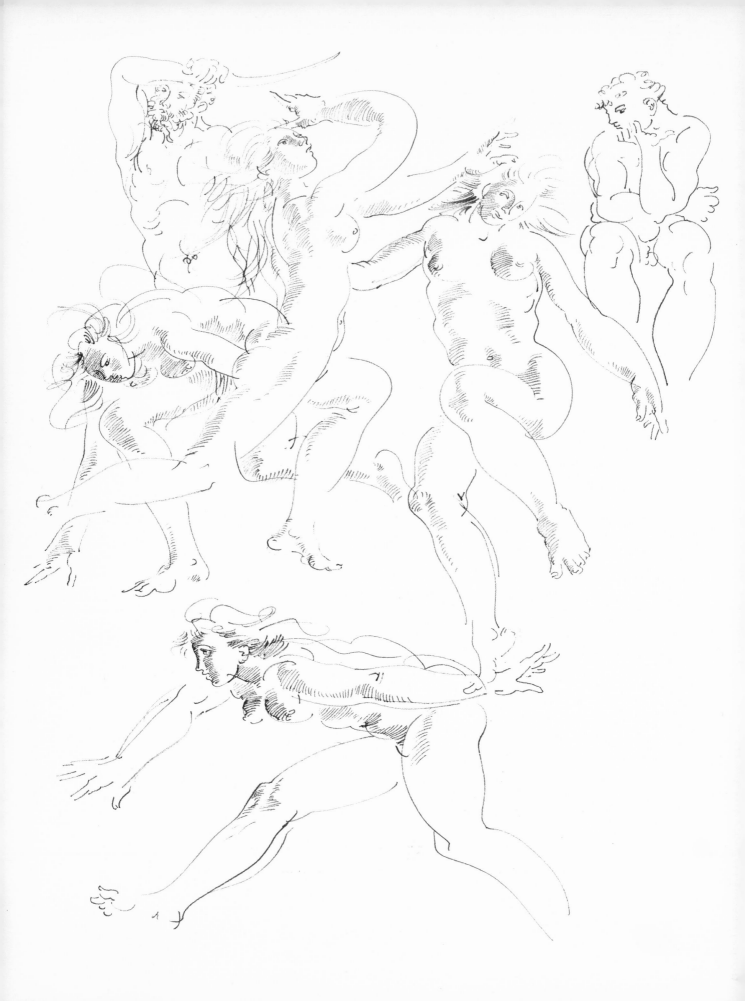

VI

Bridesmaids: But where is your beloved gone, best of women? Where has he strayed from you? Let us together aid you in your search.

Bride: My beloved has retired to his garden, to his bed of spices. There he will eat the ripe fruit and also gather lilies. I am my beloved's and my beloved is mine. He takes his pleasure among my lilies.

Bridegroom: You are beautiful, my love; as the narcissus flower, and noble as the City of Jerusalem, but terrible now as an army in battle array.
Turn your eyes away from me, lest I lose my senses.
Your hair ripples like a flock of goats bounding down from Mount Gilead.
Your teeth are white as a flock of shorn sheep come up from their washings, none of them barren, all mothers of twins.
Your cheeks are golden red like a pomegranate's rind, save for what is hidden by your tresses.
In this Palace I house sixty queens and eighty concubines and numberless virgins.
But my dove, my undefiled, is single and alone, her mother's favourite child.

Bridesmaids: Nonetheless the other women, queens and concubines, have blessed and praised her. They cry: 'Who is this who advances like the light of dawn, lovely as the moon, clear as the sun, terrible as an army in battle array?'

Bridegroom: I retired to my garden, to view the fruits of its valley, to see whether the vines were flourishing, whether the pomegranates were budding. There I lost my senses, feeling like a chariot driven by a princess.

Bridesmen: Return, return, daughter of Shulam that we may gaze on you again!

Bridegroom: What do you see in this daughter of Shulam. unless it were an army in battle array?

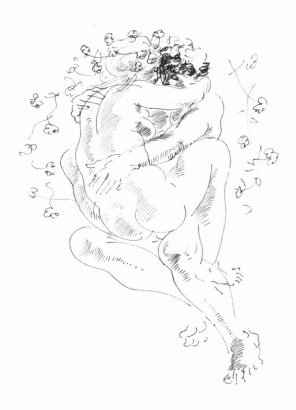

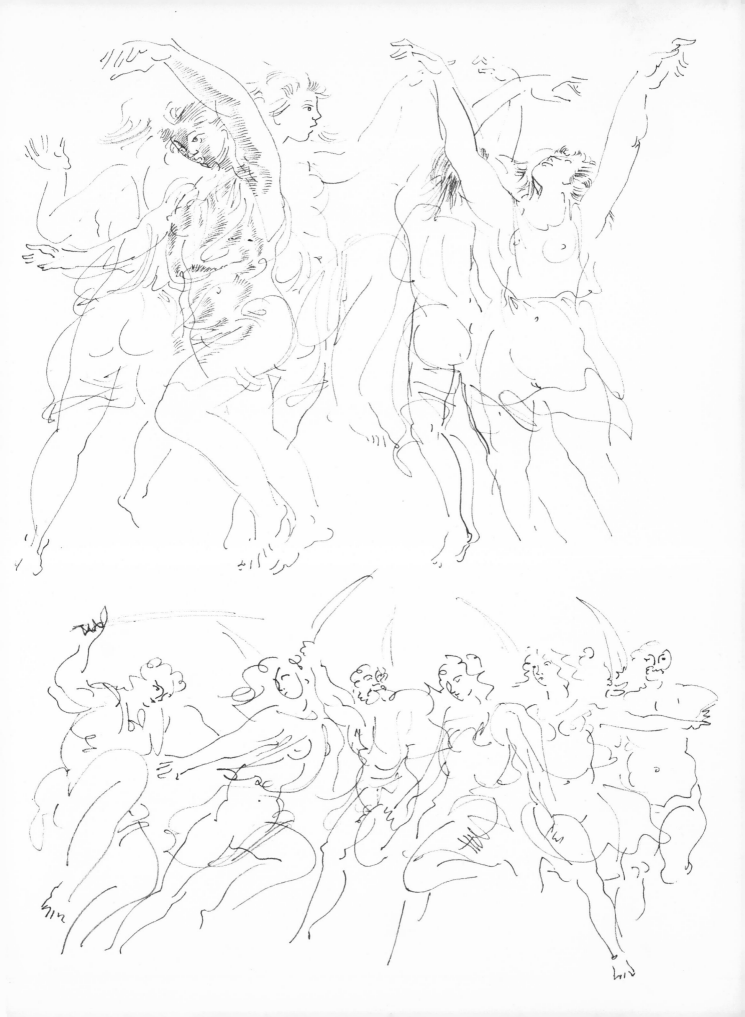

VII

Bridegroom: How beautiful, princess, are your shod feet!
The joints of your thighs are like the work of a
master goldsmith.
Your navel is like a goblet which never lacks
for liquor.
Your belly is like a heap of wheat surrounded
by lilies.
Your breasts are like young twin gazelles.
Your neck is like an ivory tower.
Your eyes are like the fishpools of Hebron by
the principal gate.
Your nose is like the tower of Lebanon which
looks upon Damascus.
Your head is like Mount Carmel and your hair
like pleats of royal purple.
How beautifully and gloriously you are made.
You are as tall as a date palm, your breasts are
like its clusters.
I said: 'I shall climb the palm tree and handle
its clusters'.
But your breasts to my touch were rather
clusters of grapes, and your breath had the scent
of quinces.

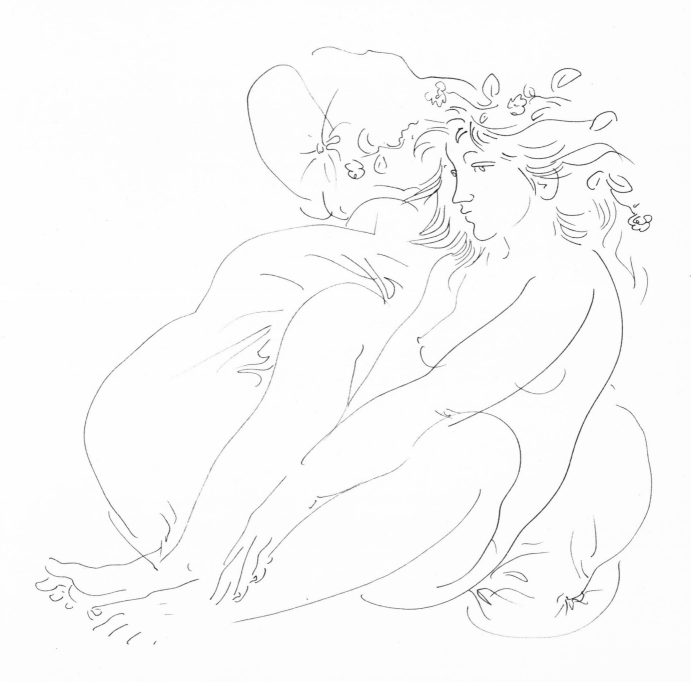

Bride: Your mouth, my beloved, will taste the best
wine, worthy of your drinking; and there will
also be food for your lips and teeth to
browse upon.
I am my beloved's and he longs for me.

Bridegroom: Come, beloved, let us wander out into the
countryside and spend our nights in villages.
We will rise early and visit the vineyards to see
how the vines are faring, whether the young
clusters are yet showing, whether the
pomegranate tree is in bud. The mandrakes are
scented, and all manner of fruit, fresh and dried,
are stores at our gates, for you, my beloved.

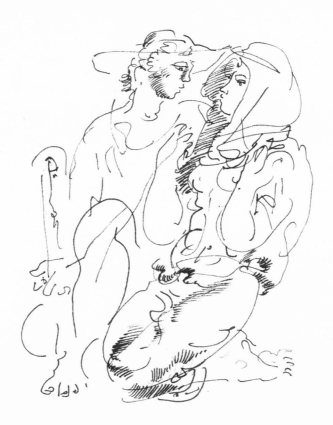

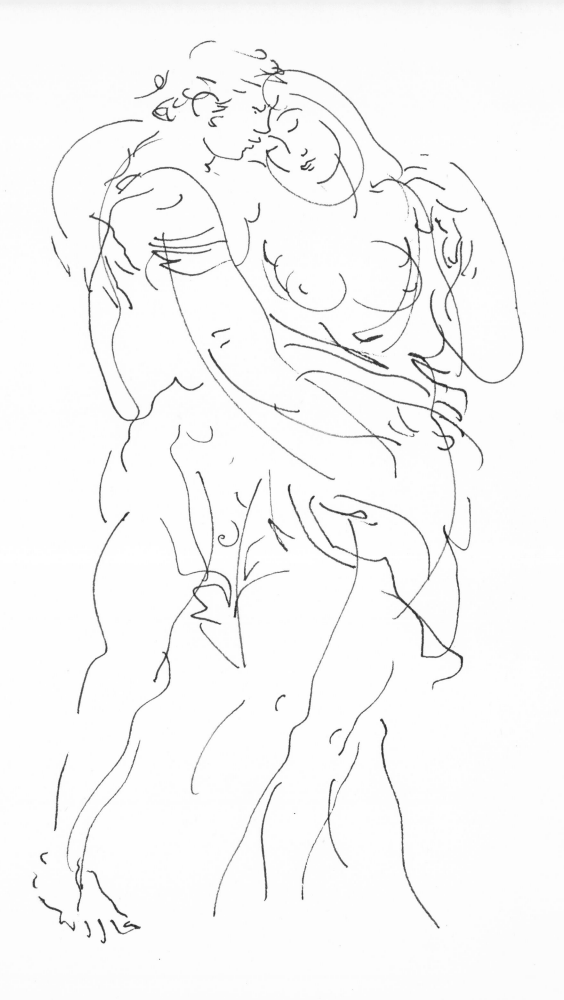

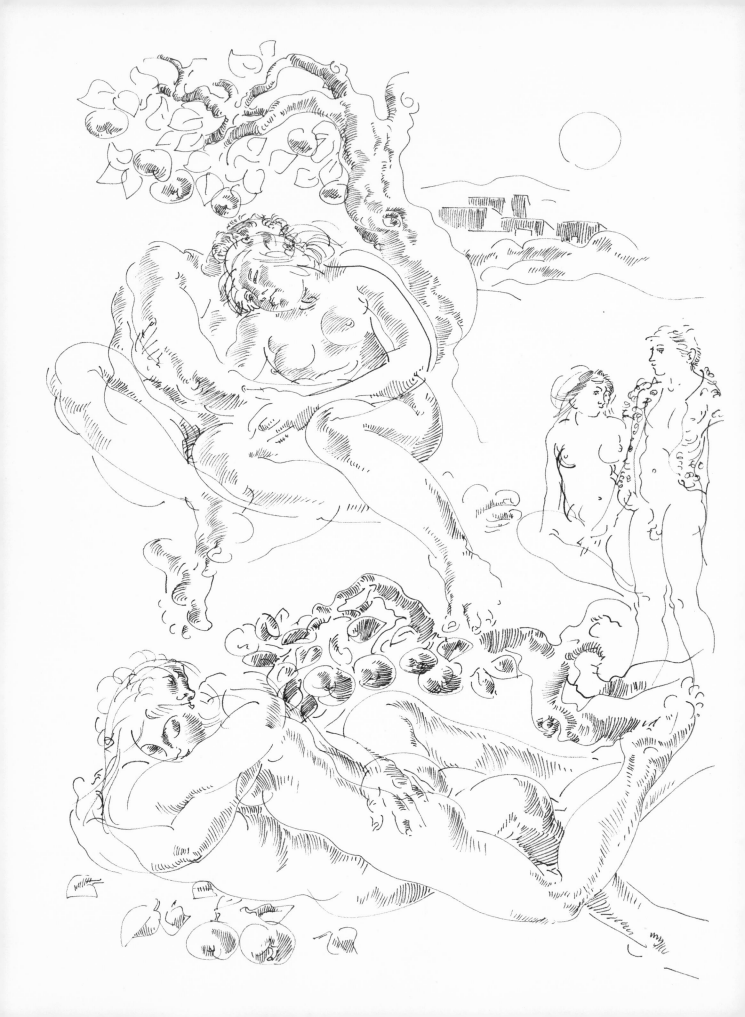

VIII

Bride: I have said in my heart 'If only you were my
brother, weaned from my mother's breasts, so
that, should I meet you outside the house, I could
kiss you and never be blamed!'
Yet now I shall take your hand, and bring you
home with me and there you shall instruct me
in love. I will give you a drink of spiced wine,
the juice of my pomegranates.
His left hand is under my head, his right hand
embraces me.

Bridegroom: Daughters of Jerusalem, I charge you not to
rouse nor to disturb my love. Let her wake when
it pleases her.

Bridesmaids: Who can this be advancing from the desert,
rich in beauty, leaning on her beloved?

Bridegroom: I aroused you where you lay under a quince
tree. There it was that Eve your mother lost
her virginity.

Bride: Wear me like a charm on your breast, or like a
phylactery on your arm.
Your love is strong as death, but jealousy is cruel
as the grave, and its embers glow with fire.
Many waters cannot quench love, neither can
floods drown it.

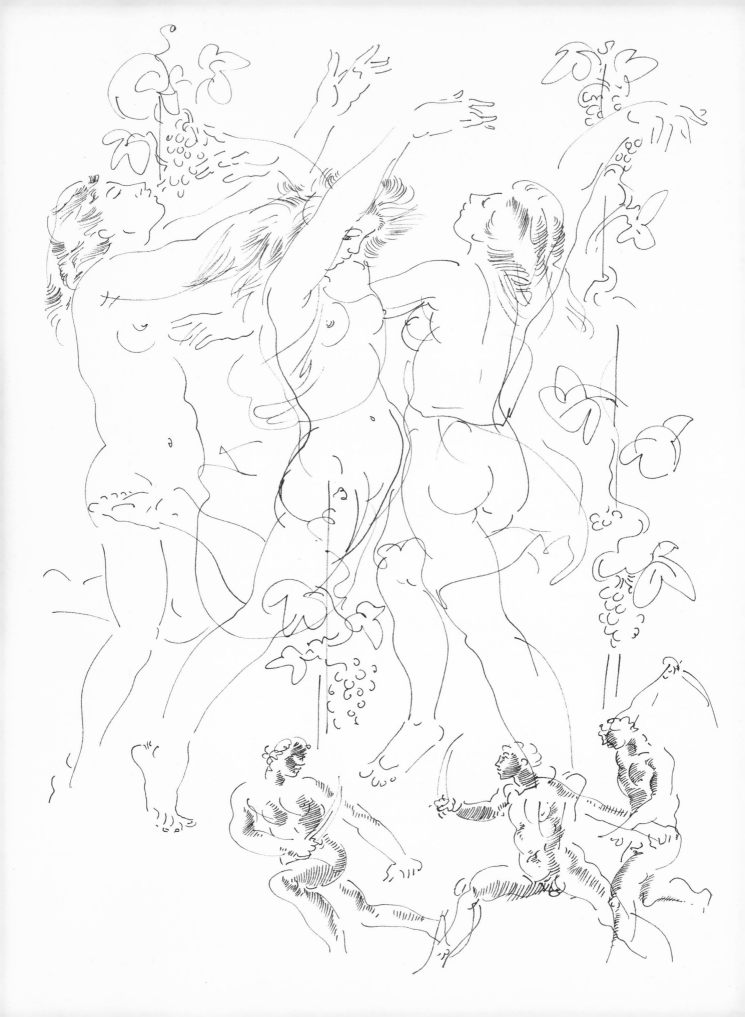

A man might well barter his house and all his
possessions for love, yet consider the
cost trifling.

Bridesmaids: We have a little sister here whose breasts have
not yet budded. What shall we do for her one
day when she is asked in marriage?

Bridesmen: Liken her to a city wall, and we will build a silver
palace for her upon it.
Liken her to a door, and we will strengthen her
with planks of cedar.

Bride: I am like a city wall. My breasts are firm as
towers. Therefore when my beloved is with me,
I restore peace, as it were.
My vineyard needs a peaceful settlement,
because of those who care for it.

Bridesmaids: She has put the vineyard in charge of her
watchmen. This man of ours offers a thousand
pieces of silver for the fruit.

Bridegroom: A thousand for the settlement and another two
hundred for the garden's watchmen! My love,
you live in these orchards; my companions are
listening. Let me hear your answer.

Bride: Only come away with me, my beloved; come
away and become like a wild goat or a hart on
my mounds of spices!

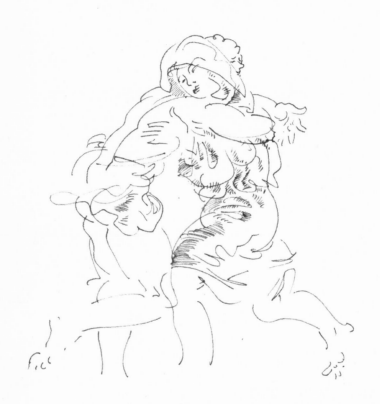